Colour Mixing Guide
Oils

Julie Collins

Search Press

First published in 2016

Search Press Limited
Wellwood, North Farm Road,
Tunbridge Wells, Kent TN2 3DR

ISBN: 978-1-78221-056-6

Suppliers
If you have difficulty in obtaining any of
the materials and equipment mentioned
in this book, then please visit the
Search Press website for details of suppliers:
www.searchpress.com

Always refer to your supplier's website or in
store for the latest ranges

Printed in Malaysia

Acknowledgements

To Winsor & Newton for kindly
supplying the paints and other
materials used in this book.

Contents

Introduction

Our lives are full of colour, yet we rarely stop to think how important it is. In art, colour is one of the key ingredients of a successful painting. A harmonious colour arrangement is crucial. In this book I will give you a basic understanding of colour: how to see colour, understand the terminology, use colour in context and, most importantly, how to mix and combine colours.

During my years of teaching art, my students have always been inspired when they have learned basic colour mixing. Immediately they begin to see huge possibilities in their painting and are amazed that this can be achieved with a limited palette and a bit of knowledge. Indeed, if you want to be a successful painter, I believe you must learn colour mixing first and painting second. It is well worth investing time familiarising yourself with the colour wheel and making colour charts.

This book includes various colour charts and can be used as a quick reference, but if you want to learn more about colour, you can use the book as a guide to how to practise colour mixing. Practice really does make perfect and the more you do it, the more colour will become second nature. You will be able to paint more intuitively as a result.

The book starts with primary, secondary and tertiary colours and the colour wheel. I use a palette of only thirteen colours and white, and show you how to create so much from them. First we take a look at complementary colours; warm and cool colours; dull and bright colours; colour tone and how to mix many yellows, oranges, reds, pinks, violets, blues, greens, browns, blacks and greys from our limited palette.

I always advise spending plenty of time mixing and testing colours before committing them to the 'real' painting. This will save hours of frustration and disappointment. After all, an athlete will always warm up and not just set off on a 100-metre sprint.

Colour mixing is best approached with enjoyment, and if you think of it as fun, you will certainly have better results.

Orange Pot

In this painting I used a limited palette and spent a long time planning the colours. I thought very carefully about using complementary colours and light and dark tones to add drama. The colours used were: cadmium orange, cadmium green pale, Winsor lemon, titanium white, French ultramarine blue and ivory black. These colours were used as follows: French ultramarine blue and white – medium and pale mixes; French ultramarine blue with a touch of ivory black for the very dark blue; cadmium green pale with Winsor lemon for the bright green; straight cadmium orange for the pot; straight white for some of the light areas; white diluted with solvent for the thinner white areas.

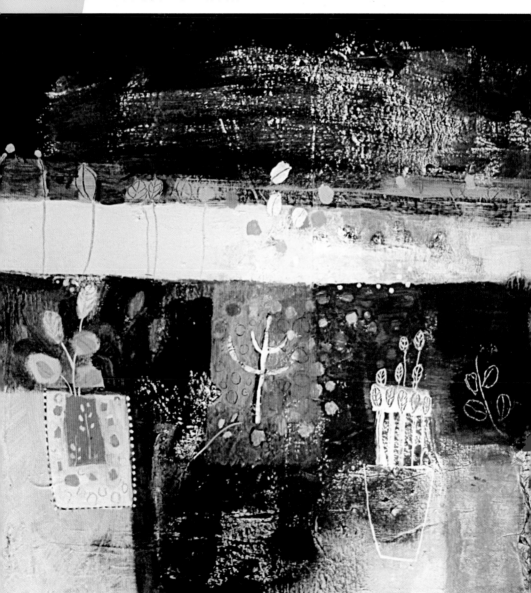

Materials

Paints

Oil paints have a thick, buttery consistency and are generally available in either tubes or large tubs. I have used the professional oil paint range in this book, which is made from better quality pigments than the students' range, which leads to better results. The students' range is still extremely good, however, and fine to use, particularly if you are a beginner. Oil paints are also available in a water mixable format, as oil bars and as fast-drying paints.

Drying time

Oil paints dry slowly as follows:

1. Fast drying = two days e.g. cobalt blue.

2. Medium drying = five days e.g. permanent alizarin crimson.

3. Slow drying = more than five days, e.g. Winsor yellows and oranges.

For further information about exact drying times, refer to the paint manufacturer's website.

Oil solvents and mediums

Sansodor Low odour solvent used to thin oil paint and clean equipment.

Distilled turpentine Fast evaporating, highly refined oil with the strongest thinning and brush cleaning power of all artists' solvents.

White spirit Volatile, flammable solvent for thinning and cleaning.

Brush cleaner A new product that is water miscible.

Linseed oil Pale viscous oil that slows drying time while imparting a tough, smooth enamel finish with no brush marks.

Poppy oil Pale oil that is good to use with whites and pale colours.

Liquin original Semi-gloss medium which speeds drying and improves the flow of the paint.

Satin varnish A varnish with a satin sheen that can be applied to a painting when it is completed.

Matt varnish Varnish without any sheen that can be applied to a painting when it is completed.

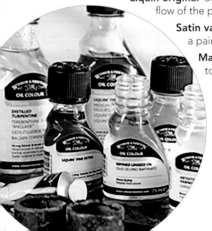

Surfaces

There are a numerous surfaces suitable for oil painting, including:

Canvas Cotton or linen, which needs to be stretched and primed before use. Alternatively, you can buy ready-primed canvases in any size.

Canvas boards Canvas already prepared on a board, ready for use. These are cheaper than canvas on a stretcher and are less bulky and easier to store.

Paper Professional artists use paper to sketch in oil. You may also use watercolour paper that has a thin coat of gesso primer.

Wooden panels These need to be prepared but can provide an excellent surface to work on.

Medium density fibreboard (MDF) This is an affordable surface to use for oil painting. It needs priming before use.

Brushes

Please use your old brushes for mixing paint. There is no need to wear out your best brushes for this task. You may also use a palette knife for mixing oil paints – particularly if you are using thick paint straight from the tube.

You can use either brushes or palette knives for oil painting. The brushes come in various sizes and styles including long- or short-handled and round, flat or filbert brush shapes.

If you make time to care for your brushes, they will last a lot longer. Cleaning and storing your brushes properly is very important.

There are many choices of brush for oil painting, from synthetic to bristle. As a general rule you get what you pay for and if you are a keen painter, it is worth investing in good brushes. I use a good make of synthetic brush and various bristle brushes.

Primers

Gesso A traditional primer made from rabbit skin glue, chalk and white pigment.

Acrylic gesso A modern acrylic primer that can be used as it is or thinned.

Palettes

You can use disposable tear-off pads, wooden, glass or transparent acrylic palettes for oil painting.

Top of page: Unprimed canvas on a roll. Above: A hog oil painting brush.

Colours used in this book

There are only thirteen colours used in this book and they are briefly explained and illustrated here.

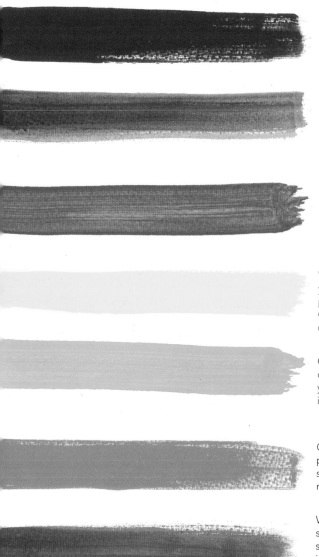

Indian red is an opaque red with a blue undertone. It is particularly useful in landscape painting and can be used to make subtle purples.

Burnt sienna is a rich brown pigment made by burning raw sienna. It has red-brown tones and is one of the two most useful colours in my palette. It is essential in landscape painting and is used to make wonderful greys.

Raw sienna is a bright yellow-brown pigment which is also essential in landscape painting. It is one of the oldest pigments and can be found in prehistoric cave art.

Winsor lemon is a very clear, bright yellow and contains some of the Hansa pigments which were discovered in Germany in the early 1900s. It can be used to mix amazing lime greens.

Cadmium yellow medium is a warm, opaque, mid-range single-pigment yellow. It is a very useful mid-yellow to include in your palette.

Cadmium orange is an opaque, single-pigment orange with a high tinting strength. It is an essential colour as it is not possible to mix an orange like this.

Winsor red is a warm mid-red and a single-pigment colour. It is a highly stable, bold, opaque red. It is very useful in flower painting and also for mixing oranges and pinks.

Permanent rose is a transparent bright rose violet made from a quinacridone pigment. It is essential in your palette for flower painting.

Permanent alizarin crimson is a highly transparent colour and a vivid red with a blue undertone. It is very useful in both flower and landscape painting.

Winsor violet (dioxazine) is a vivid, mid-shade purple. It is made from a transparent coal tar pigment and, when undiluted, it can be used as a deep black. It is essential in the flower painter's palette and good for mixing dark colours.

Cobalt blue is a clean, fresh blue. It is very useful for painting skies and other landscape features, and for mixing greys.

French ultramarine blue is a rich, bright blue – the other most useful colour in my palette. Like cobalt blue, it is essential for lanscapes, skies and mixing greys.

Winsor blue (red shade) is a deep, intense blue with a red undertone.

Colour

The colour wheel

The colour wheel is essential to understanding colour mixing and using colour. Making your own will teach you how to quickly mix tertiary colours and this will lead into the exciting world of colour mixing, so that you will no longer feel limited by primary colours.

1 Set up your palette and materials and then draw your template onto the watercolour paper.

2 First, paint the three primary colours. Be careful to keep the tone of each colour as similar as possible and clean your brush thoroughly when you move onto a new colour. Paint yellow at 12 o'clock, red at 4 o'clock and blue at 8 o'clock.

3 Next, paint the three secondary colours: orange at 2 o'clock, violet at 6 o'clock and green at 10 o'clock.

4 Last, mix the six tertiary colours: yellow-orange at 1 o'clock, red-orange at 3 o'clock, red-violet at 5 o'clock, blue-violet at 7 o'clock, blue-green at 9 o'clock and yellow-green at 11 o'clock.

Materials

Paints:

 Winsor red

 French ultramarine blue

 Cadmium yellow medium

Palette

Round brushes, sizes 6 and 2

A4 watercolour paper,
 Not surface, 300gsm
 (140lb) weight

Test paper

Turpentine or low
 odour solvent

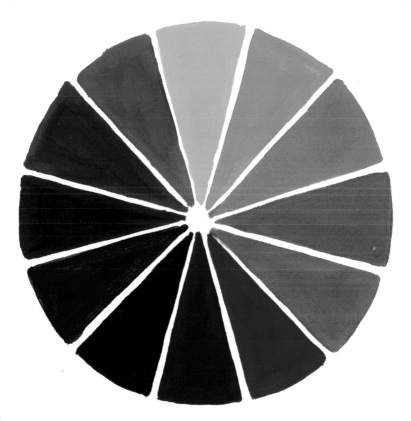

Template

Transfer this template onto watercolour paper to create your own colour wheel.

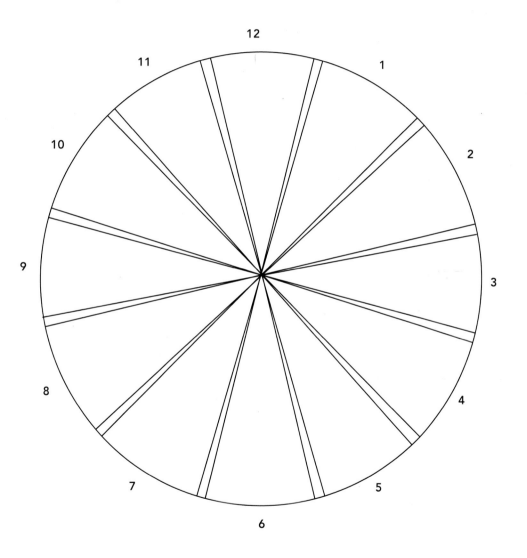

Primary colours

There is a lot to be read about the theory of colour but for the purpose of this book, I want to keep it as accessible as possible. Red, yellow and blue are the primary colours and you can mix a useful set of colours from these. These are primaries because you must have them to start with, as you cannot mix them.

Here are swatches of the two blues, two yellows and two reds used in this book. Try making the exact tone of each primary colour swatch. This will be good practice for your colour mixing later on, as you will begin to think about tone and become aware of the amount of solvent or white paint you are adding from the word go.

Begin by noticing the difference between the two blues, two yellows and two reds.

Blues

French ultramarine blue

Cobalt blue

Yellows

Winsor lemon

Cadmium yellow medium

Reds

Winsor red

Permanent alizarin crimson

Secondary colours

Secondary colours are made from mixing one primary with another in equal amounts, for example red and yellow = orange. This is fully illustrated here and can also be seen in context on the colour wheel.

Greens

French ultramarine blue + Winsor lemon 50/50

Cobalt blue + Winsor lemon 50/50

Oranges

Winsor red + cadmium yellow medium 50/50

Permanent alizarin crimson + cadmium yellow medium 50/50

Browns

Permanent alizarin crimson + cobalt blue 50/50

Winsor red + cobalt blue 50/50

Teritiary colours

Tertiary colours are created by mixing a primary colour with an adjacent secondary colour or by mixing two secondary colours together. The tertiary colours are: red-violet, red-orange, yellow-orange, yellow-green, blue-violet and blue-green. The chart below and right illustrates two of each of the tertiary colours and explains the colours used in each mix.

Yellow-orange

Cadmium yellow medium + (cadmium yellow medium + Winsor red)

Red-orange

Winsor red + (Winsor red + cadmium yellow medium)

Red-violet

Winsor red + (Winsor red + French ultramarine blue)

Blue-violet

French ultramarine blue + (French ultramarine blue + Winsor red)

Blue-green

French ultramarine blue + (French ultramarine blue + cadmium yellow medium)

Yellow-green

Cadmium yellow medium + (cadmium yellow medium + French ultramarine blue)

Yellow-orange

Winsor lemon + (Winsor lemon +
Winsor red)

Red-orange

Winsor red + (Winsor red +
Winsor lemon)

Red-violet

Winsor red + (Winsor red +
cobalt blue)

Blue-violet

Cobalt blue + (cobalt blue +
Winsor red)

Blue-green

Cobalt blue + (cobalt blue +
Winsor lemon)

Yellow-green

Winsor lemon + (Winsor lemon +
cobalt blue)

Complementary colours

When complementary colours are placed next to each other, they create the strongest contrast and enhance each other. The most common examples are:

Green with red Orange with blue Yellow with violet

The easiest way to see this is to paint examples, as shown below. Note how the blue reinforces the orange, or in other words how they literally complement each other.

Orange: Winsor lemon + permanent rose

Blue: cobalt blue

Green: Winsor lemon + cobalt blue

Red: Winsor red

Yellow: Winsor yellow

Violet: cobalt blue + permanent rose

Green: Winsor lemon + French ultramarine blue

Red-violet: Winsor red + (Winsor red + French ultramarine blue)

You can dull down a colour by adding its complementary colour to your mix. Look at the examples here and then try experimenting by making the colours for yourself. For example, if you need to create a shadow colour for your orange, then add the complementary, blue, to your orange mix.

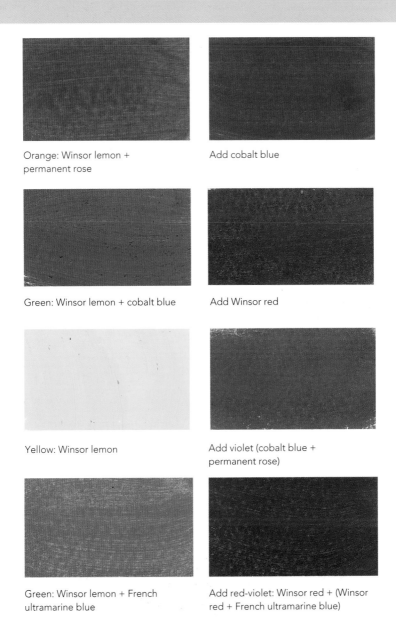

Orange: Winsor lemon + permanent rose

Add cobalt blue

Green: Winsor lemon + cobalt blue

Add Winsor red

Yellow: Winsor lemon

Add violet (cobalt blue + permanent rose)

Green: Winsor lemon + French ultramarine blue

Add red-violet: Winsor red + (Winsor red + French ultramarine blue)

Warm and cool colours

Warm colours include reds, oranges and yellows and cool colours include blues, violets and greens. However, when you consider colour more closely, there are also cool reds, cool yellows, warm blues and warm violets. See the chart below for a few examples of this.

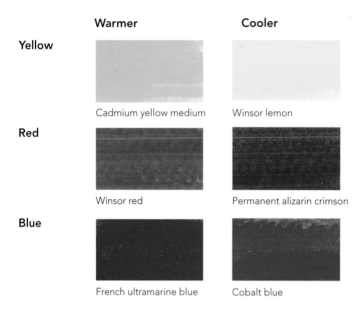

Warmer

Cooler

Yellow

Cadmium yellow medium

Winsor lemon

Red

Winsor red

Permanent alizarin crimson

Blue

French ultramarine blue

Cobalt blue

90% of the main colour + 10% of another colour to dull it

When you need to dull or modify a colour such as a yellow like cadmium yellow medium, try adding 10% of a blue such as French ultramarine blue. This creates a much more subtle colour than if you use a paint straight from the tube.

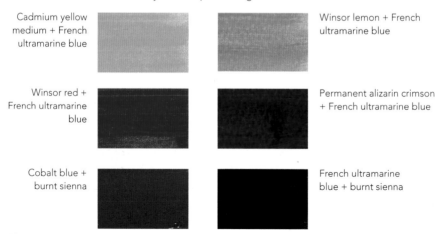

Cadmium yellow medium + French ultramarine blue

Winsor lemon + French ultramarine blue

Winsor red + French ultramarine blue

Permanent alizarin crimson + French ultramarine blue

Cobalt blue + burnt sienna

French ultramarine blue + burnt sienna

Creating interesting colour combinations in a painting

When you have familiarised yourself with the colour wheel and with secondary, tertiary and complementary colours, you will feel more confident about using different colour combinations in a painting.

Here I have created several combinations using various greys and brighter colours. I have deliberately not indicated the colours I have used as I suggest that, using the knowledge you already have alongside the information in this book, you now begin to experiment and create some of your own interesting combinations. The examples shown here have been included to inspire you and make you think about combinations that you would like to make.

Before you begin, consider the tone of the colours you will use. Then think about how warm or cool the colours are. Look at the colour charts in this book and the examples below and then try some similar exercises yourself.

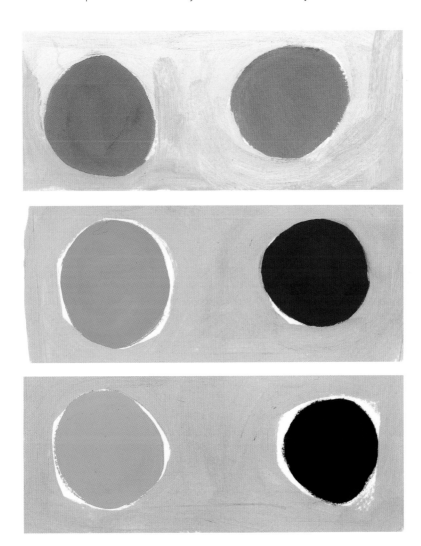

Colour tone

The tone in a painting is crucial to its success. To begin to assess tone accurately, start by making tonal colour swatches, as shown here. This is not as easy as it looks but is an excellent exercise to help you understand tone. To start with, choose one colour and gradually add white to make as many tonal swatches as you can. Then mix a colour and add white in the same way to see how many different tones of this mix you can make.

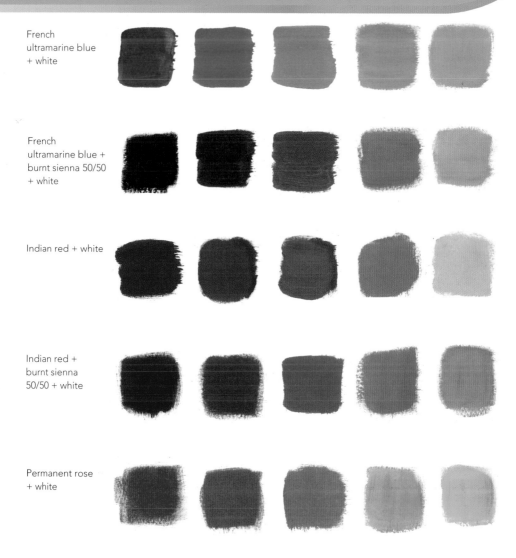

French ultramarine blue + white

French ultramarine blue + burnt sienna 50/50 + white

Indian red + white

Indian red + burnt sienna 50/50 + white

Permanent rose + white

In this exercise, choose one colour or a mix and gradually add turpentine or low odour solvent to make as many tonal variations as you can.

French ultramarine blue + solvent

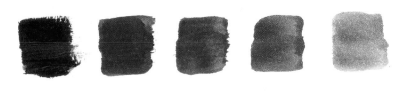

French ultramarine blue + burnt sienna 50/50 + solvent

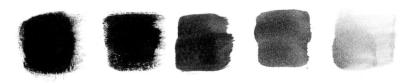

Indian red + solvent

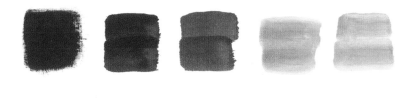

Indian red + French ultramarine blue + solvent

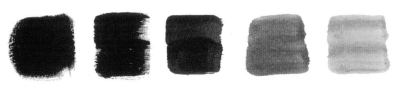

Indian red + French ultramarine blue + cadmium yellow medium + solvent

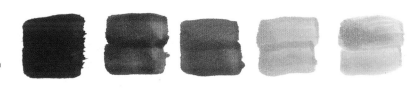

Using a limited palette

Painting with a limited palette has the advantage of creating harmony in your work. You will have to work harder to mix the colours that you need, but this means that you will also learn a great deal about colour along the way!

If you try this, you will be amazed at just how many colours you can create from only one red, one yellow and one blue. The charts below illustrate this for you and these charts do not include tonal variations of each mix, so the possibilities are almost endless. Working with one red, one blue and one yellow, I have created charts for you to use. The charts work as follows:

1 Pure colour

2 Colour + 10% of next colour

3 Colour + 20%

4 Colour + 30%

5 Colour + 40%

6 Colour + 50%

7 Colour + 60%

8 Colour + 70%

9 Colour + 80%

10 Colour + 90%

Winsor blue (red shade) + cadmium yellow medium

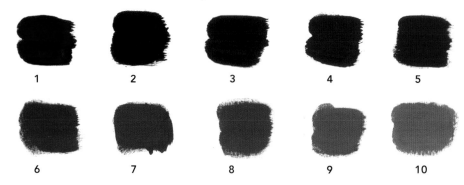

| 1 | 2 | 3 | 4 | 5 |
| 6 | 7 | 8 | 9 | 10 |

Indian red + cadmium yellow medium

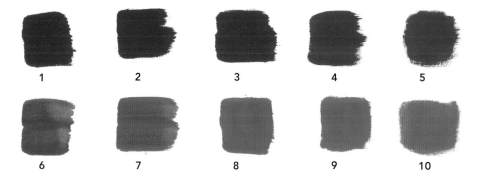

| 1 | 2 | 3 | 4 | 5 |
| 6 | 7 | 8 | 9 | 10 |

French ultramarine blue + Indian red

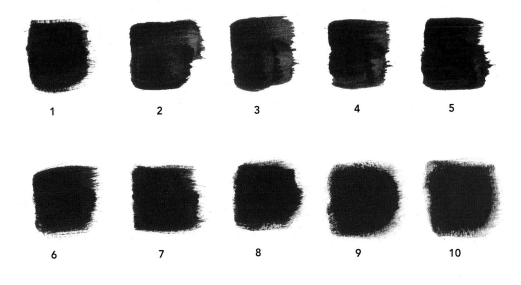

1 2 3 4 5

6 7 8 9 10

Winsor lemon + Indian red

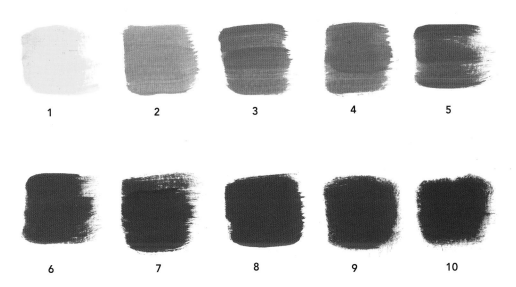

1 2 3 4 5

6 7 8 9 10

Winsor blue (red shade) + Winsor lemon

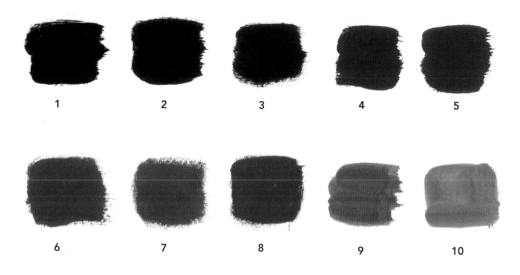

1 2 3 4 5

6 7 8 9 10

French ultramarine blue + Winsor lemon

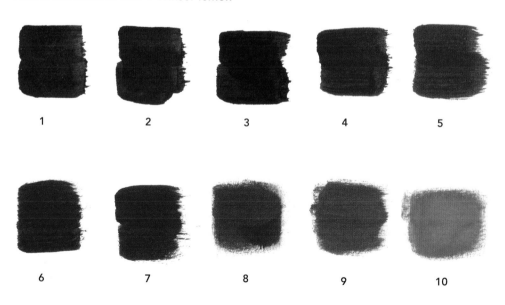

1 2 3 4 5

6 7 8 9 10

French ultramarine blue + Winsor red

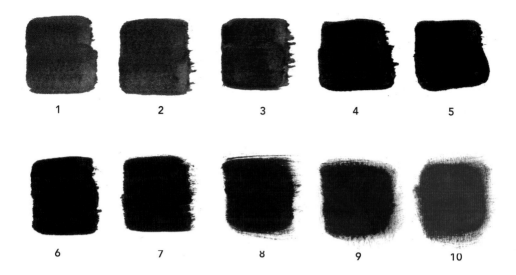

1 2 3 4 5

6 7 8 9 10

Winsor red + Winsor lemon

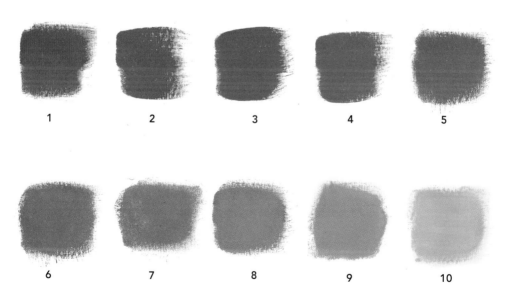

1 2 3 4 5

6 7 8 9 10

Dull and bright colours

When we refer to 'dull' colours, we really mean 'less bright'. When we refer to 'bright' colours, we must remember that the brightest colours are the pure pigments that come straight from the tube, and we can't make these colours any brighter. However, we can dull them. We may be tempted to use black to dull down a colour, but black will deaden colours. It is better to darken a colour by adding the opposite colour in the spectrum, e.g. we can add blue or violet to yellow-green or yellow-orange mixtures. This will dull the colour as if it is in shadow, but it will still be colourful. See the examples below and then see if you can think of some of your own.

Permanent rose

Winsor red

Permanent alizarin crimson

Reds

Here I have added a touch of French ultramarine blue to each red in the swatch below to show you how to dull a colour.

Indian red

Indian red + cadmium yellow medium + French ultramarine blue

Indian red + French ultramarine blue

Indian red: dull and bright mixes

Here I have shown you pure Indian red; Indian red with cadmium yellow medium and French ultramarine blue; and Indian red with French ultramarine blue. You can see how adding certain colours can dull down a colour. As you look down this chart, I have progressively added white which shows how adding white can brighten your dull colour.

Local colour

To make the most of the colours in your paintings, you always need to consider the relationships between them. Notice in the simple examples below how a colour will appear to be completely different when placed next to another colour – it may appear brighter, lighter, darker or cooler depending where it is in your picture.

Winsor lemon with French ultramarine blue

... with cobalt blue

... with cadmium orange

... with Winsor red

Winsor violet (dioxazine) with cadmium orange

... with Winsor lemon

... with cadmium yellow medium

... with raw sienna

Winsor red with cobalt blue

... with French ultramarine blue

Permanent alizarin crimson with cobalt blue

... with French ultramarine blue

Permanent rose with cobalt blue

... with French ultramarine blue

Colour mixes

The next part of this book is dedicated to colour mixing in the following format: start with one pure colour, then add 20% of another colour, then add 40%, then add 60%, lastly add 80%.

Yellows and oranges

Winsor lemon + cadmium yellow medium

+ raw sienna

+ cadmium orange

50/50 Winsor lemon + cadmium orange + titanium white

Cadmium yellow medium

50/50 cadmium yellow medium + burnt sienna

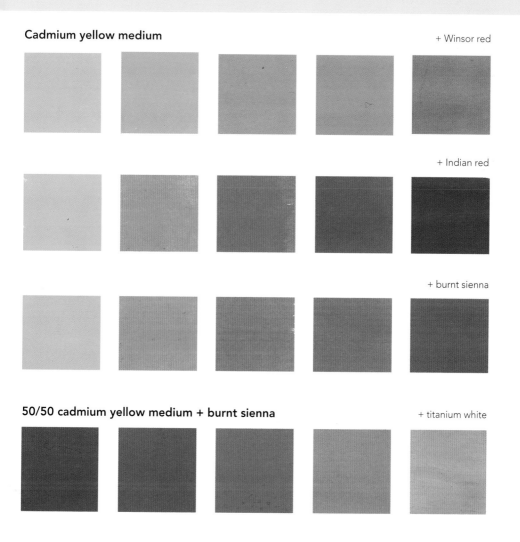

Raw sienna

50/50 raw sienna + Indian red

+ titanium white

Cadmium orange

+ permanent rose

+ permanent alizarin crimson

+ Winsor red

50/50 cadmium orange + permament rose

+ titanium white

Reds and pinks

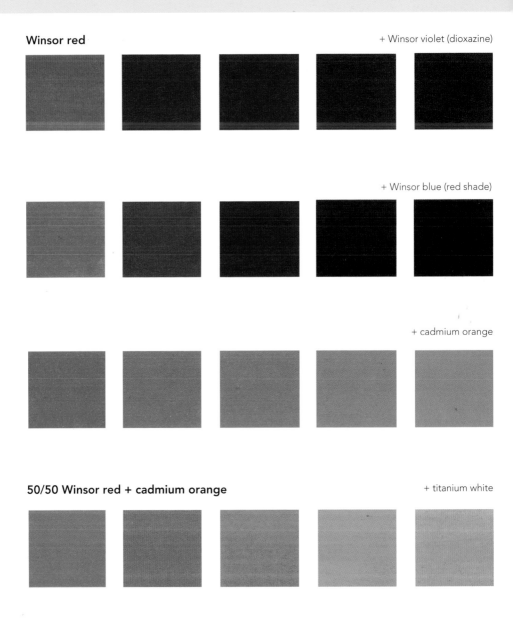

Winsor red

+ Winsor violet (dioxazine)

+ Winsor blue (red shade)

+ cadmium orange

50/50 Winsor red + cadmium orange

+ titanium white

Permanent rose

+ cadmium orange

+ Winsor violet (dioxazine)

50/50 permanent rose + Winsor violet (dioxazine) + titanium white

Permanent alizarin crimson

+ Winsor violet (dioxazine)

+ French ultramarine blue

50/50 permanent alizarin crimson + French ultramarine blue

+ titanium white

Indian red

+ Winsor red

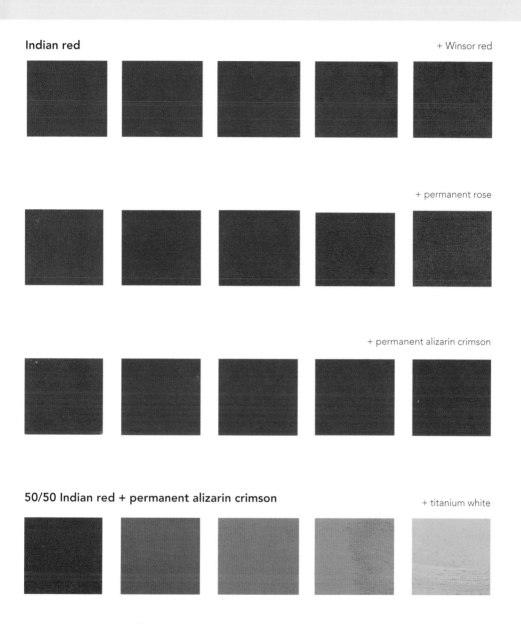

+ permanent rose

+ permanent alizarin crimson

50/50 Indian red + permanent alizarin crimson

+ titanium white

Violets and blues

French ultramarine blue

+ cobalt blue

+ Winsor blue (red shade)

+ permanent alizarin crimson

50/50 permanent alizarin crimson + French ultramarine blue

+ titanium white

36

Cobalt blue

+ permanent alizarin crimson

+ permanent rose

+ Winsor red

50/50 cobalt blue + permanent rose

+ titanium white

Winsor blue (red shade)

+ permanent alizarin crimson

+ permanent rose

+ Winsor red

50/50 Winsor blue red shade + Winsor red

+ titanium white

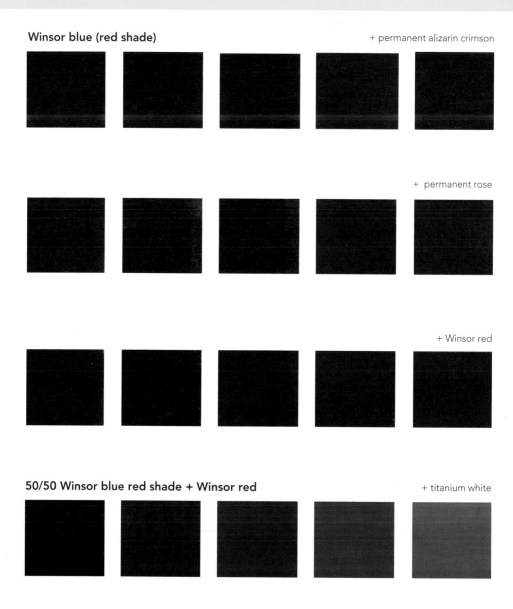

Winsor violet (dioxazine)

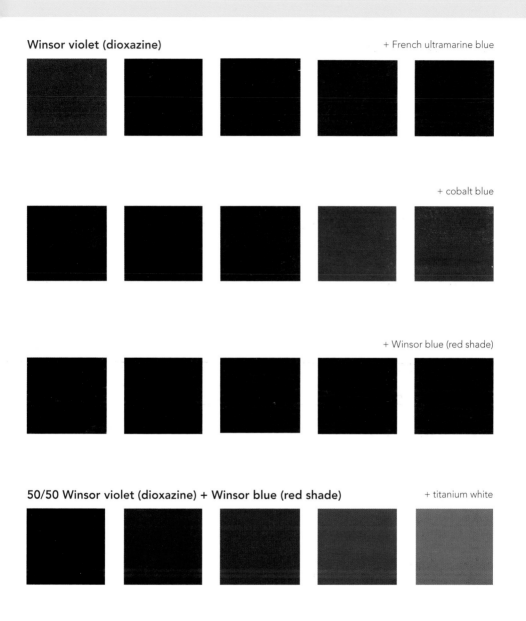

+ cobalt blue

+ Winsor blue (red shade)

50/50 Winsor violet (dioxazine) + Winsor blue (red shade)

+ titanium white

Greens

French ultramarine blue

+ Winsor lemon

+ cadmium yellow medium

+ raw sienna

50/50 French ultramarine blue + Winsor lemon

+ titanium white

Winsor blue (red shade)

+ Winsor lemon

+ cadmium yellow medium

+ raw sienna

50/50 Winsor blue (red shade) + Winsor lemon

+ titanium white

Cobalt blue

+ Winsor lemon

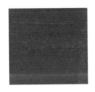 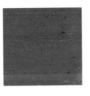 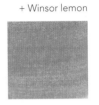

+ cadmium yellow medium

+ raw sienna

50/50 cobalt blue + raw sienna

+ titanium white

Winsor blue (red shade) + raw sienna

+ titanium white

Cobalt blue + cadmium yellow medium

+ titanium white

Cobalt blue + burnt sienna + cadmium yellow medium

+ titanium white

Browns

Burnt sienna

Indian red

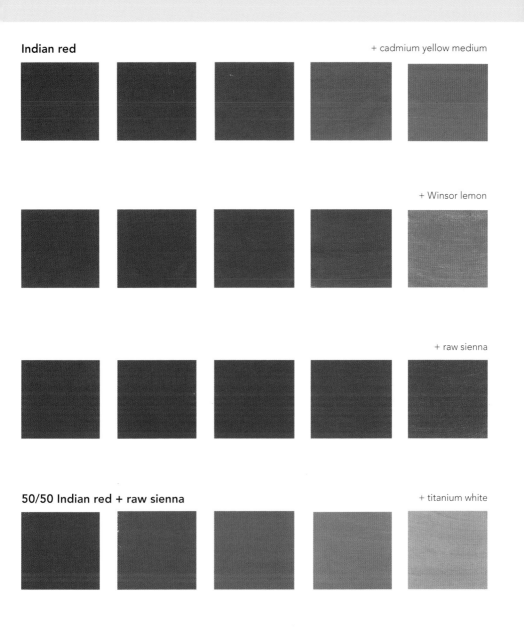

+ Winsor lemon

+ raw sienna

50/50 Indian red + raw sienna

+ titanium white

Blacks and greys

Burnt sienna

+ French ultramarine blue

+ cobalt blue

+ Winsor blue red shade

50/50 burnt sienna + French ultramarine blue

+ titanium white

Winsor blue (red shade)

+ burnt sienna + burnt sienna + + Indian red + Indian red +
 raw sienna raw sienna

French ultramarine blue

+ burnt sienna + burnt sienna + + Indian red + Indian red +
 raw sienna raw sienna

French ultramarine blue + burnt sienna + raw sienna + titanium white

French ultramarine blue + Indian red + raw sienna + titanium white

47

Glossary

All of these terms are explained in the context of oil painting.

Acrylic gesso A white acrylic primer.

Artisan varnish Varnish used to give gloss finish to an oil painting.

Bristle brush A coarse-textured brush made of bristles.

Canvas Cotton or linen, primed ready to use for oil painting.

Canvas board Canvas on a board, prepared ready to use for oil painting.

Colour wheel A wheel that includes the three primary, three secondary and six tertiary colours. Essential to understanding colour mixing (see page 10).

Filbert A narrow flat brush with a rounded shape.

Flat brush A brush with a flat or square end.

Impasto The technique where paint is laid on very thickly and brush or knife strokes are visible.

Liquin impasto A medium used to build texture and retain brush strokes.

Liquin oleopasto A medium used to build texture and retain brush strokes.

Local colour How one colour affects another in a picture or particular context.

Opaque A non-transparent colour, where paint does not allow the white of the paper or canvas to shine through.

Palette The surface on which you lay out and mix your colours, which can be a plate or a glass or wood surface.

Permanent A light-fast colour such as permanent alizarin crimson. The old alizarin crimson could fade in daylight.

Primed A surface protected by a coat of white acrylic primer before painting with oils.

Professional range The highest quality paints with the purest pigments.

Round brush A brush with a round shape and a point.

Sansador A low odour solvent used to thin oil paints.

Single pigment Paint made from one pure pigment.

Spectrum The range of colours the human eye can see, as in a rainbow.

Staining Paint that stains the paper or your clothes easily, and cannot be removed.

Students' range A less high quality, but a good and more affordable range.

Synthetic brush A brush made from acrylic or another synthetic material.

Tone How light or dark a colour is.

Transparent Paint that you can see through, which allows the white of the paper or canvas to shine through.

Tubes Paint sold in tubes is soft but will harden when it comes in contact with air.

Turpentine Solvent used to thin oil paint and clean equipment.

White spirit The cheapest solvent, used to clean equipment.

48